Lettering

—FOR—

ABSOLUTE
BEGINNERS
WORKBOOK

Lettering for Absolute Beginners Workbook is an original work, first published in 2020 by Fox Chapel Publishing Company, Inc. The patterns contained herein are copyrighted by the author. Readers may make copies of these patterns for personal use. The patterns themselves, however, are not to be duplicated for resale or distribution under any circumstances. Any such copying is a violation of copyright law.

ISBN 978-1-4971-0052-7

Bible quotes: King James Version (quote on pages 17–19, page 173); Christian Standard Bible (quote at bottom of page 19); English Standard Version (pages 35, 39, 158, 167); and New King James Version (page 173).

Images from *www.Shutterstock.com*: slava17 (light brown wood background 2, 4, 31, 35); rangizzz (cards with paperclip 4); Aleksandr Pobedimskiy (gray wood background behind supplies 8, 11, 14, 17, 22); Buniak Andrii (bag with bow 27); akiyoko (pencils 28); David Ryo (gel pens 29); Olga Kovalenko (chalk 29); Thanagon Poungbubpchart (charcoal pencils 30); Photo Melon (cardstock 32); FocusStocker (pencil 32); SuwannaPhoto (bags 33); Olga Popova (mug 33); Pataradon (plate 33); and Maceofoto (chalkboard 33).

To learn more about the other great books from Fox Chapel Publishing, or to find a retailer near you, call toll-free 800-457-9112 or visit us at *www.FoxChapelPublishing.com*.

We are always looking for talented authors. To submit an idea, please send a brief inquiry to acquisitions@foxchapelpublishing.com.

Printed in China
Third printing

Lettering
— FOR —
ABSOLUTE
BEGINNERS
WORKBOOK

Complete Faux Calligraphy
How-to Guide with Simple Projects

DANIELLE STRINGER

Fox Chapel
PUBLISHING

Table of Contents

170

but first, pray

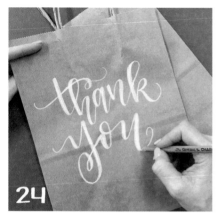

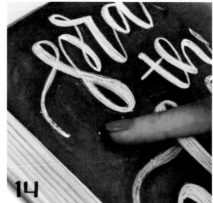

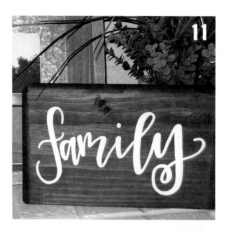

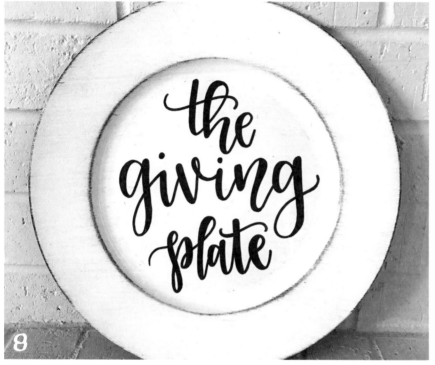

Introduction

Hey there, creative! Before you pick up a pen, I want you to be encouraged. If you are an absolute beginner to the world of lettering, this book was created just for you. I'm not sure if I should say this, so shhhhh! I have never taken a calligraphy class! I know I'm writing a book on lettering, but I need to be real with you! I'm not overly trained in all the lettering ways, but I think that is what makes me the perfect teacher for you as a beginner. I remember knowing nothing about calligraphy and teaching myself the basics. I remember practicing endlessly until I got that perfect "S" shape. I also remember the feeling of pride I got when I completed my first project. Lettering has grown to be such a fun, creative outlet for me, and I'm so excited to share it with you.

When I first began, I was lettering on chalkboards and wood signs. Because I wanted to create art on larger mediums than just pen and paper, I knew I had to find a way to get the look of beautiful lettering without using the usual brush pens that calligraphy calls for. I discovered a method of calligraphy that is in a sense "faking it." The term you will see used for this method is "faux calligraphy." It takes calligraphy and breaks it down into a simple drawing of the letters and thickening of the downstrokes. I couldn't believe how similar it looked to modern calligraphy! The best part is that I was able to begin lettering on all sorts of mediums. Now I've worked on everything from chalkboards, windows, mugs, metal, wood, fabric, and even my mailbox. If you are anything like me, you will start walking around stores thinking, "Hmmm, I wonder if I could letter on that?"

Since growing my sign business, I began getting requests to teach how I made them. I remembered how excited I was to learn this method for our signs, and I knew I had to share it with others. I began to pull back the curtain and give away all my secrets to lettering. What I found was a new love for seeing the faces of my students light up when they see how easy it is to create lettering they thought was so difficult. Some sign makers that had only used stencils and vinyl are now lettering their signs instead!

If you enjoy crafting already, faux calligraphy will be such a fun addition to your projects! One of my favorite things about lettering is personalization with gift giving. Later in the book I will guide you through a few projects and show how you can take your gift giving to the next level by adding lettering to the mix.

I hope this method will take away any intimidation you may feel! We won't be using brush pens or calligraphy nibs. (And if you don't know what those are, don't worry!) This book will give you the bare basics of lettering and build your confidence to move up to those tools. Will it take practice? Absolutely! This book is your launching pad. Jump in knowing that your practice is making progress, and your lettering will continue to "flourish."

Facing page: Faux calligraphy allows you to letter on many large-scale surfaces. Although calligraphy and brush pens would work on this kraft paper, it's much easier to create oversized hand-lettered works of art when you use a regular fine-point marker.

The Giving Plate

I must warn you that something will change in you after completing this project. When you master the skill of writing on plates, you will walk around stores thinking, "Hmmm, could I write on that?" The inspiration for this project is an example of just that! I was in a local craft store and saw these charger plates. I immediately thought about a traditional one I had seen online called "The Giving Plate." It's an extra sentiment when you are cooking for a friend or family member who needs some TLC or for use during the holidays.

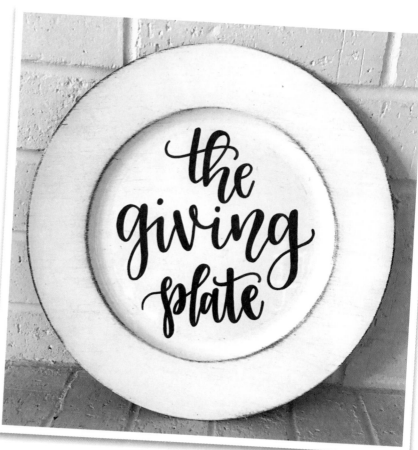

materials

* Ceramic charger plate
* Paint pen or permanent maker
* Paper towel

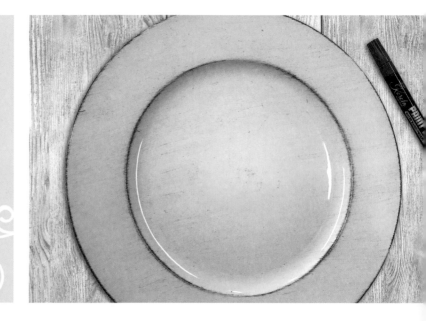

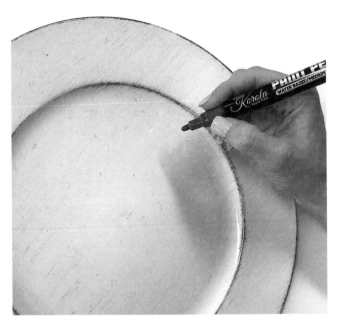

1. Pick out your favorite water-based paint pen (my favorite for this project was the Korola brand pictured) and a clean, dry plate.

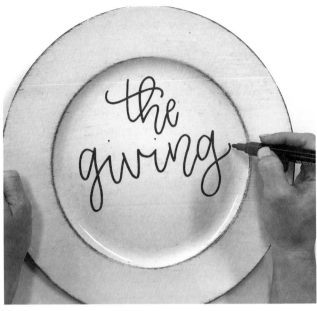

2. Begin lettering the bones of your design on the plate. You don't have an option to sketch it out beforehand, but you can easily wipe away any mistakes with a wet paper towel.

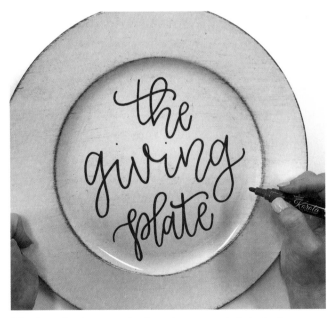

3. Let the bones design dry completely before you create the body.

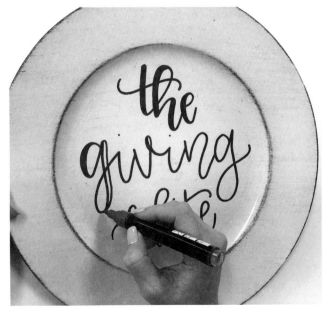

4. Add the thickness to your downstrokes and make that lettering come to life!

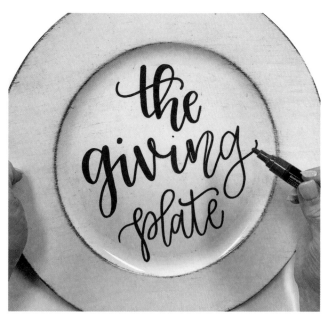

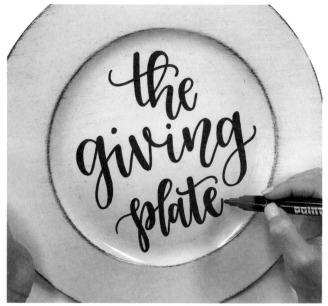

5. Go slow and take it one letter at a time. Remember, you can still use your wet paper towel for any mess-ups to the body.

6. Finish your plate! Bake it to seal the design, make it waterproof, and safe for food. Follow the manufacturer's instructions on the temperature and length to bake your plate.

Hand-Lettered Home Décor

This project will add a very pretty, rustic touch to your home décor. You can find a stained piece of wood or something similar from your local craft store, ready to letter on. I cut, sanded, and stained this one myself because I liked the idea of customizing the size to suit the lettered design I had in mind. I could also choose a wood stain color that matched the rest of my décor.

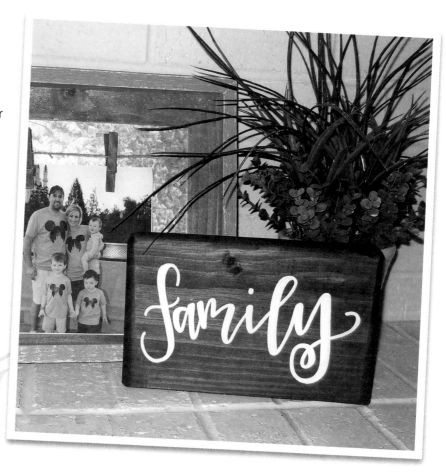

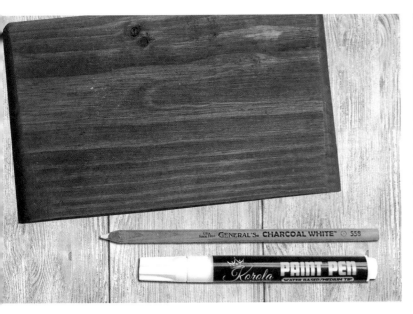

materials

* **Stained wood block**
* **White charcoal pencil**
* **White paint pen** (water-based paint pens seem to work best for me)
* **Wet napkin or a baby wipe**

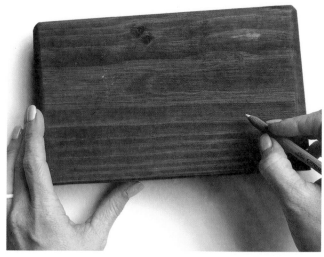

1. Choose or make a piece of stained wood. Clean with a dry cotton rag (like an old T-shirt) to rid your wood of any dust. Even if you don't think your wood is dirty, don't skip this step.

2. Decide which one- to three-word phrase you will letter on your block. I chose *family* to pair with a family photo in our home.

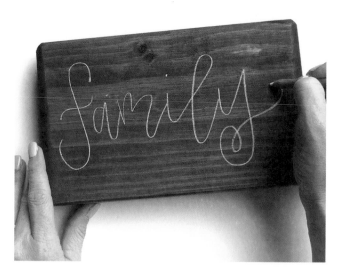

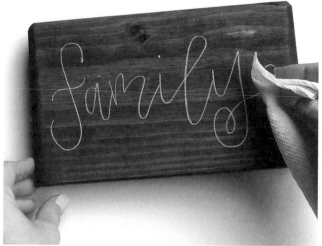

3. Lightly letter your word on the block using the white charcoal pencil. Spread out your letters to ensure there will be space to add your downstrokes.

4. Use a wet napkin or baby wipe to erase the charcoal pencil as many times as you need. This is where the light lettering is an advantage. If you press too hard, it could dig into the wood and leave a mark when you try to erase your mistakes.

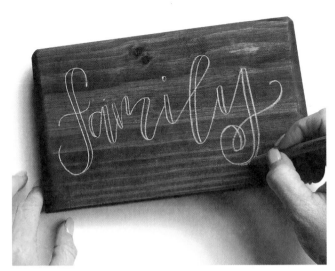

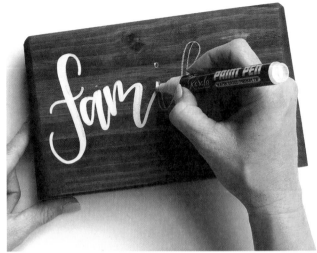

5. Once you are satisfied with your bones, add the body of your letters one at a time by drawing your new lines on the downstrokes. Do not fill in the strokes with your charcoal pencil, because it could clog up your paint pen in the next step.

6. Grab your paint pen and trace over each letter while filling in the downstrokes. Make sure to take this one letter at a time so you don't smudge the paint with your hand.

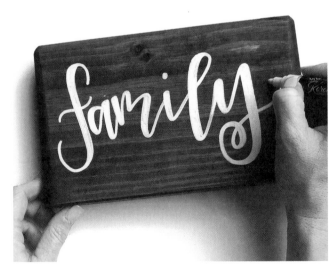

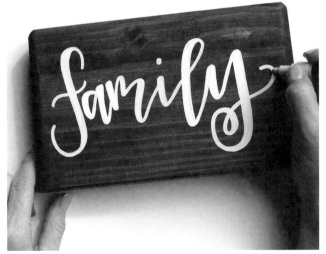

7. Complete the first coat of the design and let dry.

8. After the first coat has completely dried, begin a second coat. This will cover any streaks that may have shown through the first coat. Allow the second coat to dry. Your sign is complete!

Chalkboard Sign

Chalkboards are so fun because they aren't permanent. You can display a different Bible verse weekly (or even daily!) or the lyrics of a song that's stuck in your head. The best thing about this project is the changeability of it; you can change your hand-lettered chalk messages regularly or on a whim!

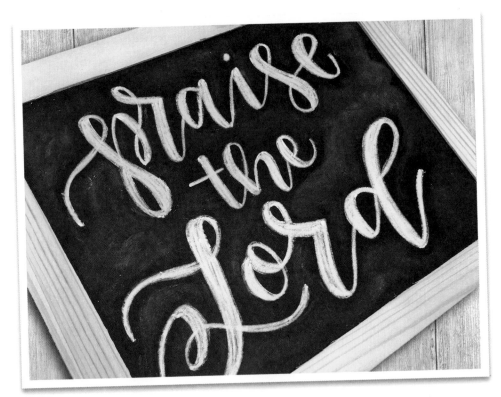

materials

* **Chalkboard**
* **Chalk**
* **Pencil sharpener**
* **Paper towel**
* **Water**

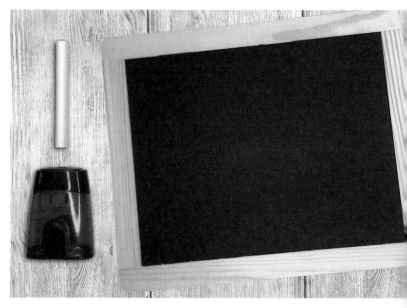

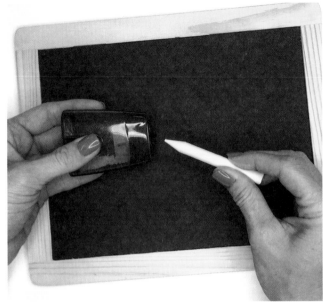

1. Sharpen your chalk to a point. You can use a regular pencil sharpener for this, be careful not to break off the tip.

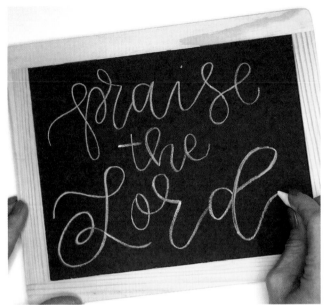

2. Sketch out your design.

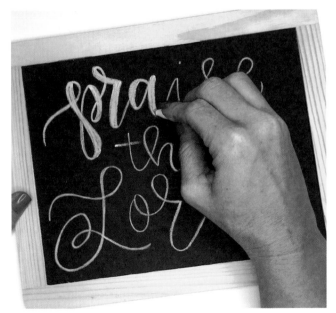

3. Shade in your downstrokes. Make sure your hand doesn't come in contact with the chalkboard. If you're having trouble with this, try elevating your hand by placing a book under your forearm.

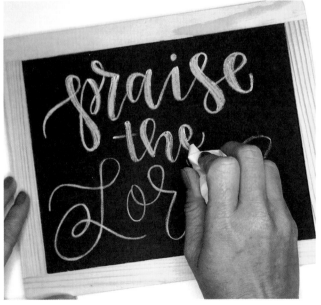

4. Fix any mistakes with a wet paper towel.

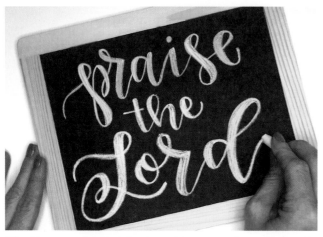 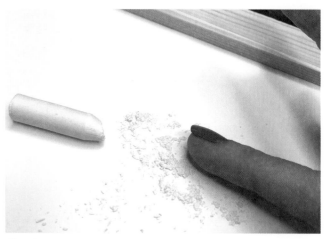

5. You can be finished at this stage if you wish. If you want to learn how to add an extra touch with shading, read the following steps.

6. Grind up some chalk and dip your fingertip in the resulting chalk dust.

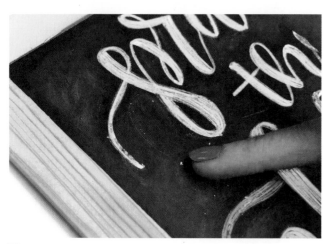 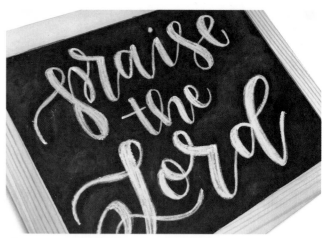

7. Begin lightly shading around your letters. Again, make sure you avoid touching your lettered message with your palm or arm.

8. Now you're done! Display your hand-lettered chalkboard sign where family or friends can enjoy it.

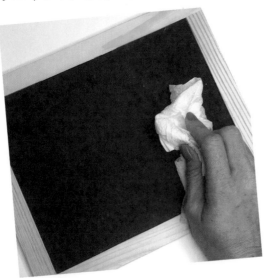

Erase and repeat as many times as you want! This is the best part about having a chalkboard around. You can always change your sign to speak to the season of life you are in.

Bible Journaling

This project is near and dear to my heart. I recently realized just how much Scripture I had memorized simply by lettering them on signs. When we letter, it takes time. This time can be spent really meditating on what we are writing and soaking in the application for it in our lives. You can be as simple or wild as you like with Bible journaling. I always keep it simple by making the words I'm lettering the main focus.

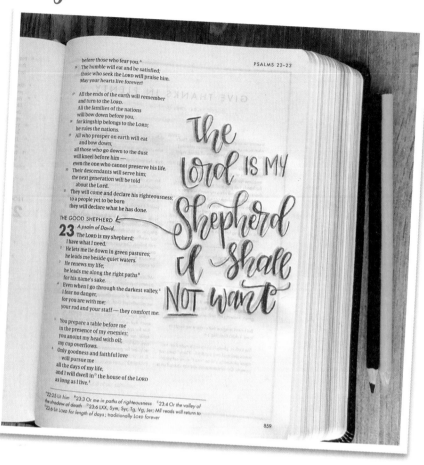

materials

* **Bible (with wide margins or a journaling Bible are a big bonus)**
* **Colored pencils**
* **Eraser**

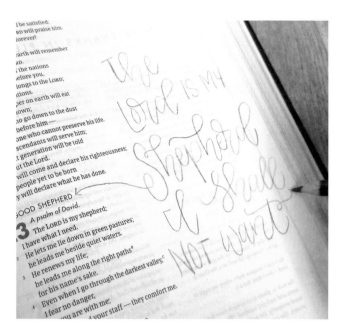

1. Find the Scripture or theme that speaks to your soul. Choose the color you will use, and letter your Scripture in the margin of the Bible with the colored pencil.

speak life

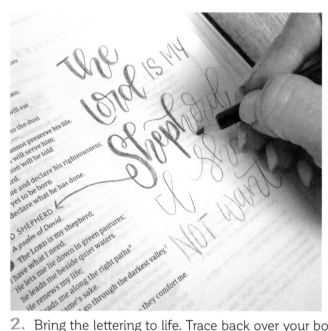

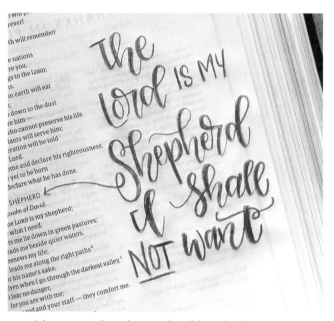

2. Bring the lettering to life. Trace back over your bones with your colored pencil, adding boldness and thickness to your downstrokes.

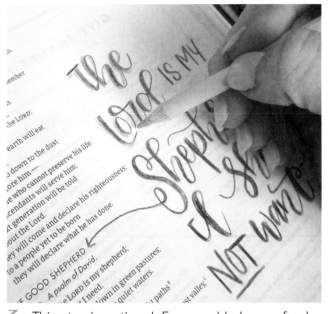
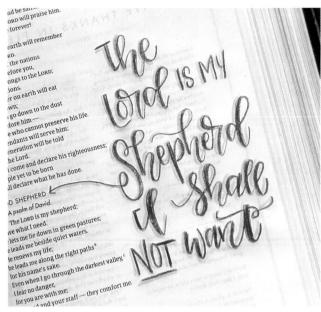

3. This step is optional. For an added pop of color, you can choose another color to highlight your scripture. Choose either the left or right side of your letters to shade. I chose the left side. Either way works, just stay consistent throughout the whole Scripture.

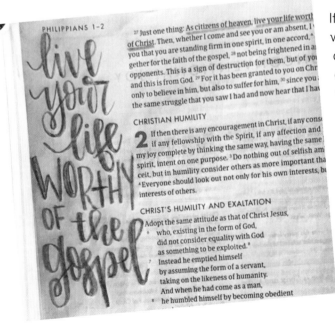

If you don't have colored pencils on hand while reading your daily Scripture, you can still letter! I have done so on the spot during a church service when all I had was a pencil nearby. The important thing is that you are able to connect your faith to your creativity. This can also be so therapeutic! These pages in your Bible will begin to catch your eye and remind you of what God spoke to your heart in that moment. Lettering after reading Scripture helps messages that resonate with you while reading to stay at the forefront of your mind, even well after you've closed your Bible.

Gift Giving

Your gift giving just got an upgrade! Hand lettering adds a personal touch to any form of packaging or gifting. In my sign business, I get more comments on my packaging than my actual products. Don't underestimate the value of a thoughtful extra touch like a hand-written note or name on a gift bag or tag.

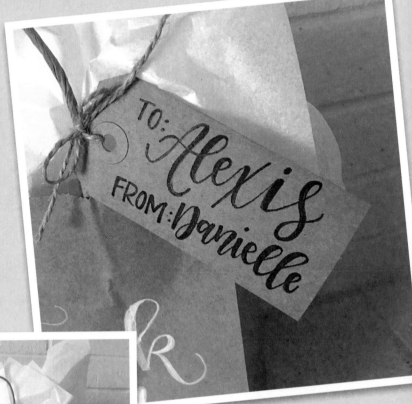

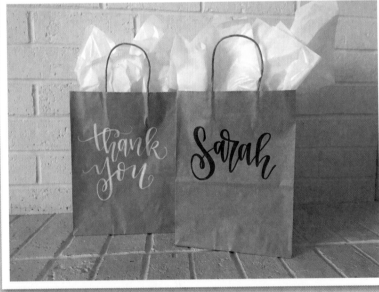

I will show you two ways to letter a gift bag! See page 22 for the white charcoal option and page 24 for the permanent marker option.

thank you

Gift Tag

Gift tags are a fun addition for any gift giver to add. They're super simple and easy to make, so making more than one will be a snap!

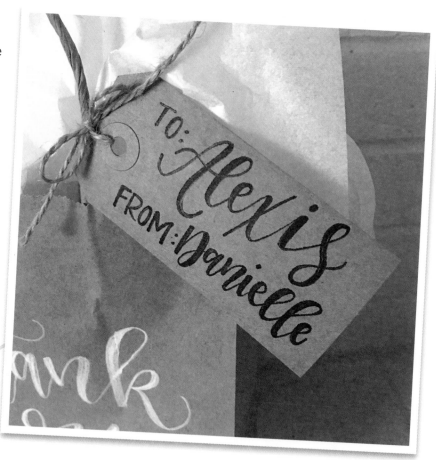

materials

* **Kraft gift tags**
* **Pencil**
* **Eraser**
* **Ultra-fine tip permanent marker**
* **Twine**

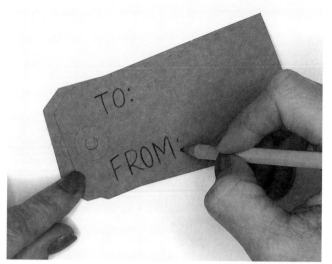

1. Grab your pencil and begin with "To" and "From" lightly in print. I always start gift tags this way so I have a nice reference point and know I won't run out of space. I also like to make the gift receiver's name larger, so I line up the "To" and "From" with the top and bottom edges of the tag.

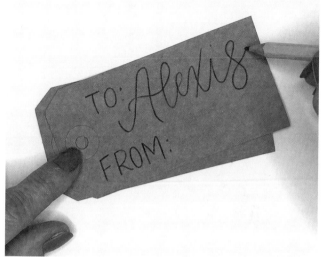

2. Sketch out the lettering of the names (again, *lightly*). Don't worry about messing up! Erase any mistakes with your pencil eraser.

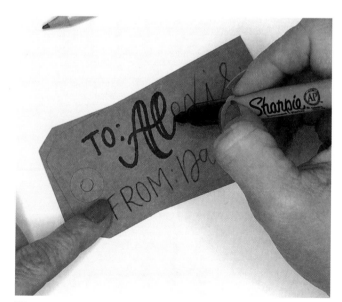

3. Trace over the penciled letters with your permanent marker. Add the body to each letter's downstrokes as you go.

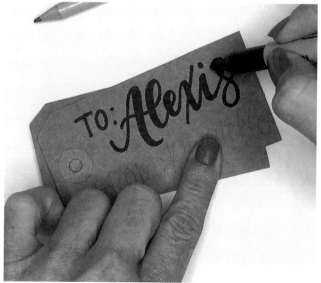

4. Remember to keep your letters smooth by rounding out the new lines you draw and bringing them into your upstrokes. After the ink dries, you can erase any pencil marks that are still visible. Use twine to attach the gift tag to your gift bag.

Gift Bags

Want to make your gift even more special? A handcrafted gift bag will always elevate your gift giving. The best part is that it's very easy to do! All you need are a few tools and a blank kraft paper bag.

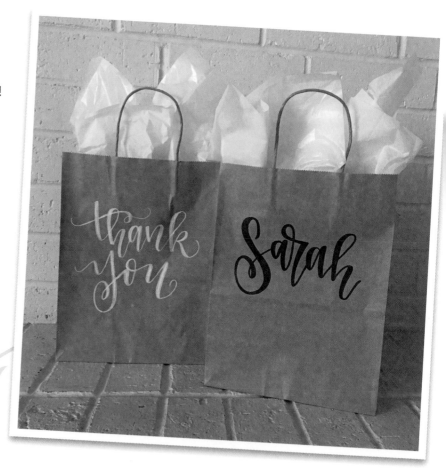

materials

* **Kraft paper gift bag**
* **White tissue paper**
* **White charcoal pencil**
* **Eraser**
* **Fine-tip permanent marker**

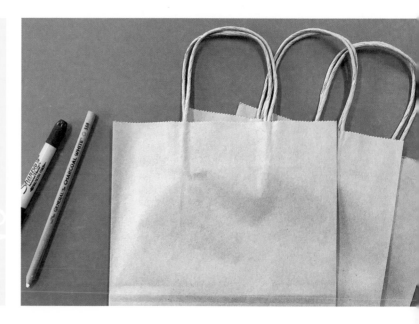

Option 1: White Charcoal Message

If you like the look of white charcoal pencil on the kraft paper, follow these steps. If you would prefer a bolder look, see page 26 for instructions on how to make a lettered message with a permanent marker.

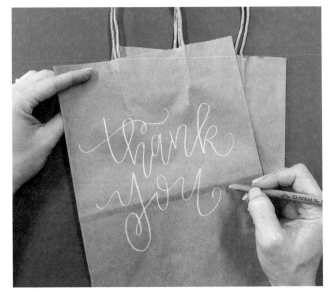

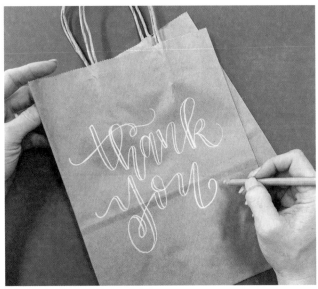

1. Use the charcoal pencil to sketch out your message. I chose "thank you" and I plan to pair it with my personalized gift tag. Space out your letters enough to add in the thickness in the next step. The charcoal pencil is erasable, so erase any mistakes and letter until you're happy with the result.

2. Create the body of your letters by adding new lines on each downstroke with your charcoal pencil. Remember to keep a balanced word by looking at your original bones and asking yourself where the best place to thicken will be. In some cases, you may just retrace the downstroke right next to the original line.

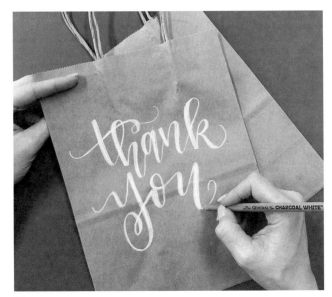

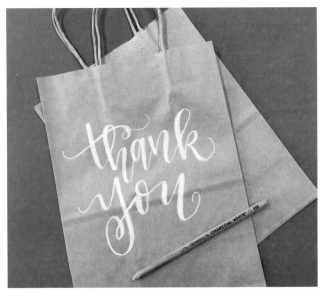

3. Complete your design by filling in the downstrokes. Keep your letters smooth by continuing the same long downstrokes and not coloring up and down.

4. You're done! Bag your gift, add tissue paper, and watch your recipient beam with joy.

Option 2: Permanent Marker Message

Another option for this project is using a permanent marker. Here is an example of lettering a name onto the kraft paper bag using the charcoal pencil as the bones and a permanent marker to finish it. Don't be afraid to use colored permanent markers to make your lettered design stand out even more.

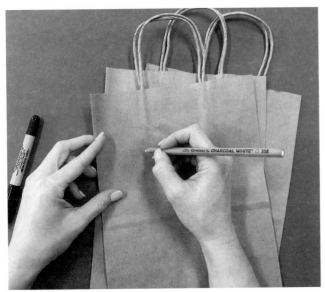 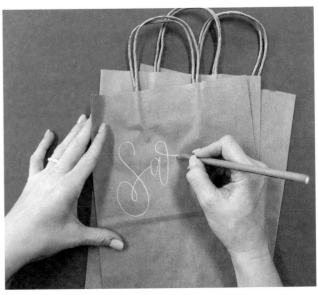

1. As with Option 1, begin lettering the bones with a white charcoal pencil. I chose the name Sarah for this example because it's short and sweet. If you're writing a longer name, sketch it out on another paper first for practice, to avoid having to reach for the eraser too much.

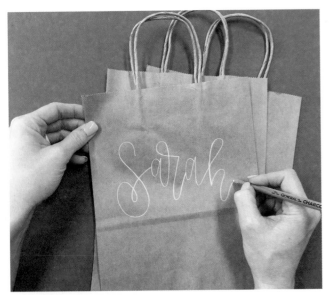 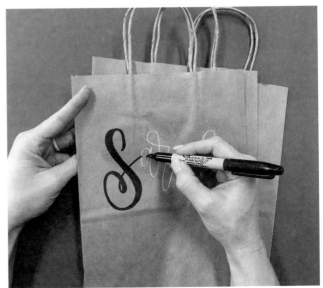

2. You're done with the charcoal pencil now. Make sure there aren't any mistakes you need to erase or areas you need to touch up.

3. Use the permanent marker to go over your white charcoal bones, adding the body of the letters as you go.

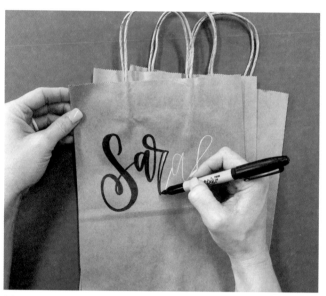 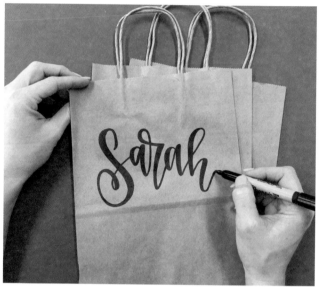

4. Continue to add the body as you go slowly, letter by letter, since you won't be able to erase any mistakes. On occasion, you might find that you want to add a bit more curve to your lines than you had originally drawn while doing the bones.

5. It's as simple as that! Fill your bag with the gift and tissue paper, and hand it over to the lucky recipient.

Decorate your bag with a bow!

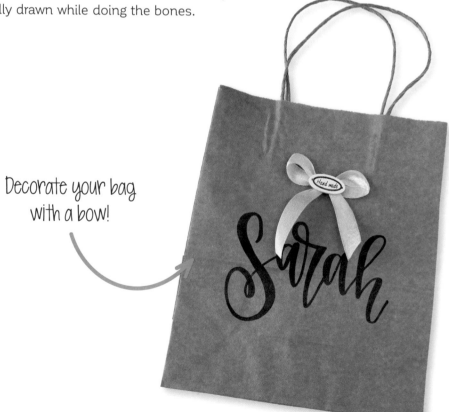

The Basics

To get started with faux calligraphy, you want your tools to have one feature: monoweight.

Monoweight means a line that is one weight, or thickness. No matter how much pressure you apply with the pen, the ink output will be the same—it won't have a thicker or thinner section as you pull it across the page. This will open up your options to most common pencils and pens that you can find at any retailer where office and art supplies are sold.

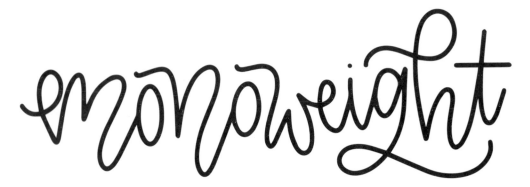

Supplies

Here are some of my favorite lettering tools.

- **Pencils:** With a pencil, you can create without the worry of messing up. Use any graphite pencil that can be easily erased. For my wood signs, I love to draw a design in pencil before I paint it. This lets me perfect the layout before I make it permanent by erasing and redrawing until I get it just right.

- **Gel pens:** Gel pens are great when you're lettering on paper, doodling, or note taking. I also love to use them for addressing envelopes. They come in fun colors and can really make your lettering pop! Let your ink dry in order to avoid smudging.

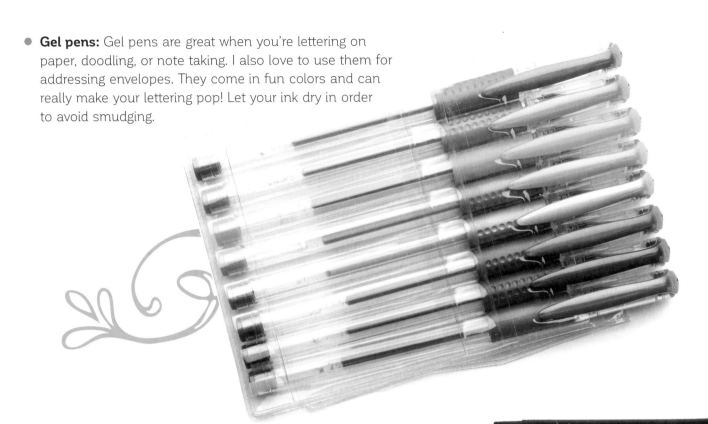

- **Paint pens:** There are two types of paint pens: oil based and water based. My personal preference is water based. I use them for all my wood signs. They are also great for ceramics, metal, and glass. Oil-based paint pens can also be used for the same projects. They are just a little thicker and take longer to dry.

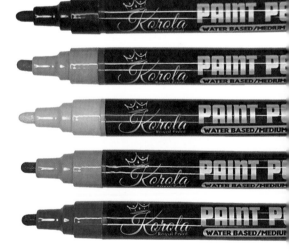

- **Chalk:** With chalk I have one big tip: sharpen it! You can actually use a pencil sharpener. A sharp piece of chalk gives you much more control over the placement of your lines and makes the design more detailed.

- **Charcoal pencils:** You will see these used in some of the projects in the back of the book. Think of them like a chalk pencil. They can be used on wood to outline your design before you commit to making it permanent. You can also use them alone to create a chalk effect on your paper art.

down Strokes thicker

calligraphy

up Strokes thinner

Traditional calligraphy is based on thin upstrokes—where you move the pen up away from you—and thick downstrokes—where you move the pen down toward you. With brush pens and calligraphy pens, the thickness of the strokes is determined by the angle and amount of pressure applied to the tool. By using monoweight tools, this book will focus on how to create the look of calligraphy without all the "pressure."

Facing page: The trick to modern faux calligraphy is to make sure you only thicken your downstrokes and leave the upstrokes thin.

Where to Begin

The first thing you need to do is shake out your hand before you begin lettering. Losten up! Relax the muscles in your neck, arm, and hand. Try not to be tense because you'll find your lettering will come out stilted and shaky. Go with the flow!

I recommend using cardstock and a pencil when you're beginning to draw your letters. When I make mistakes, I like to use those big pink erasers you probably remember from school. When you are happy with your design, trace over your penciled "bones" (or preliminary drawing, kind of like a sketch) with a permanent marker to bring the letters to life. If you feel really confident, you could begin with an ultra-fine tip permanent marker instead of a pencil.

There is a word practice section in this book (page 152) that will serve as a great starting point for common words.

When choosing your lettering projects, your chosen medium should have a smooth surface. Some common materials are ceramic, kraft paper, chalkboards, and smooth wood. With the exception of ceramic and chalkboards, most projects will allow you to draw your design in pencil first. Keep a pencil sharpener and that trusty pink eraser handy to perfect your design before you make it permanent with ink or paint.

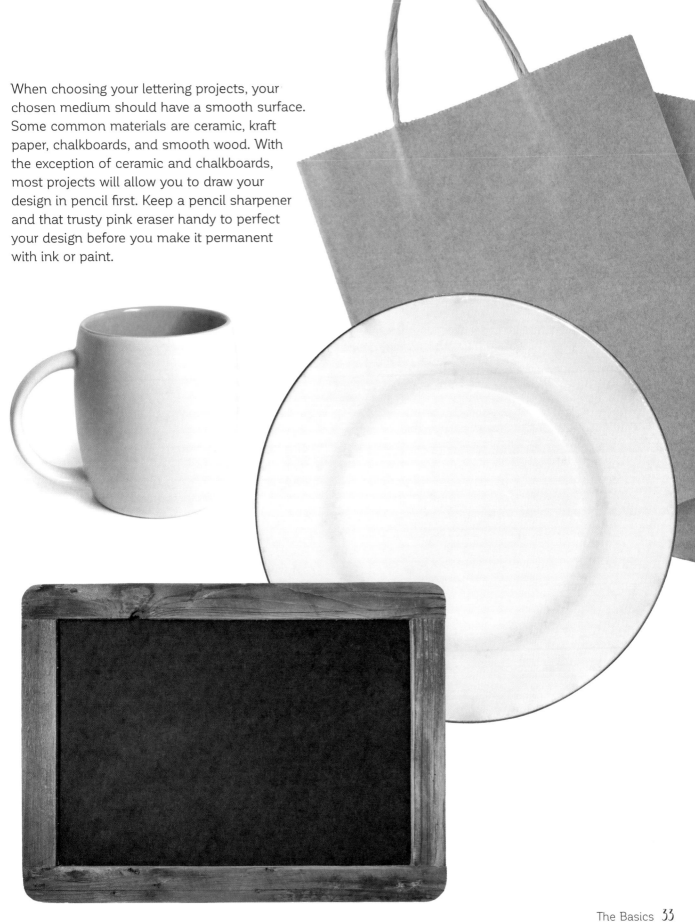

The Breakdown

Think of letters as having two parts: bones and a body.
First, draw the basic letter shape to create the bones.

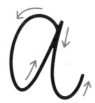

Then add the body by drawing extra lines on the downstrokes.

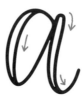

Fill in the downstrokes to complete the calligraphy look. This simple
process brings your letter to life and creates the look of modern calligraphy!

Facing page: Giving your hand-lettered piece a "sketchy" look can add to its overall artistic appeal.

The Lord
will
fulfill
His purpose
for me

PSALM 138:8

Space It Carefully

Remember, you are *drawing* the letters, not *writing* them. Be sure to spread out your letters enough to have the space to add the thickness to the downstrokes. Also, consider the flow of the letters and keeping them evenly spaced out. My favorite thing to say in classes is to think about it, but don't think too hard. It's much better to go with the flow and erase than to overthink and have jagged lines.

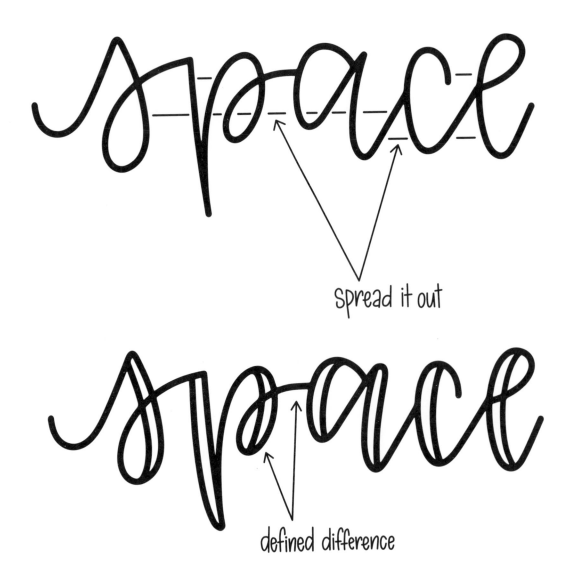

spread it out

defined difference

One question I always get asked is, "Should I add the line to the inside or outside of the letter?" Your focus is to simply make the downstrokes thicker, so the answer to that question varies by what the original bones you drew look like. Here are some examples of three different sets of bones.

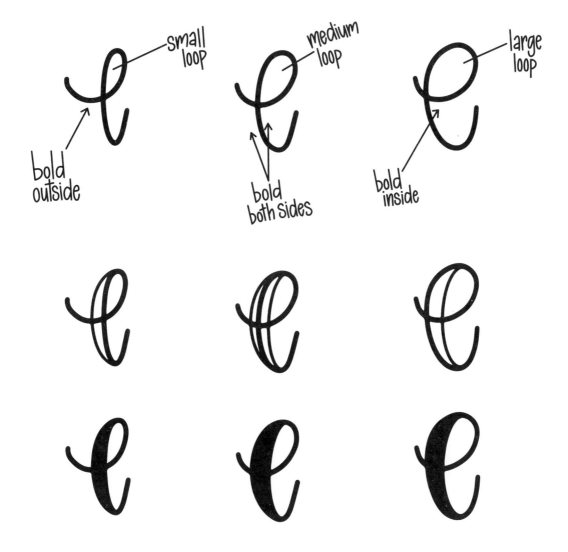

Notice they all end up looking similar. Just focus on retracing your original downstrokes in a new area to create thickness.

Smooth It Out

The goal of this method is to create the illusion that you never picked up your pen while drawing the letters. Another thing to consider is rounding out your bold sections. Make them smooth!

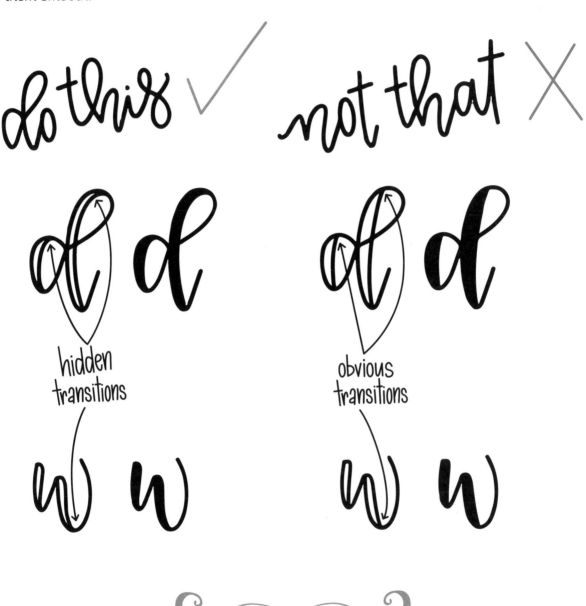

Now let's practice on some alphabets!

draw near to God and He will draw near to you

JAMES 4:8

Make sure you're creating smooth transitions with each letter, as I did with the letters in this hand-lettered quote.

Now You Try It!

A A A A _____

B B B B _____

C C C C _____

Now You Try It!

D D D D D

E E E E

F F F F

Now You Try It!

G G G G _____

H H H H _____

I I I I _____

Now You Try It!

\mathcal{J} \mathcal{J} \mathcal{J} \mathcal{J} _____

\mathcal{K} \mathcal{K} \mathcal{K} \mathcal{K} _____

\mathcal{L} \mathcal{L} \mathcal{L} \mathcal{L} _____

Now You Try It!

M M M M _____

N N N N _____

O O O O _____

Now You Try It!

\mathcal{P} \mathcal{P} \mathcal{P} \mathcal{P} \mathcal{P} _____

Q Q Q Q _____

R R R R R _____

Now You Try It!

S S S S _____

T T T T _____

U U U U _____

Now You Try It!

V V V V

W W W W

X X X X

Now You Try It!

uppercase 1 bones

A B C D E

F G H I J

K L M N

O P Q R S

T U V W

X Y Z

you add the body!

go for it!

A _ _ B _ _ C _ _ D _ _

E _ _ F _ _ G _ _

H _ _ I _ _ J _ K _

L _ _ M _ _ N _ _

O _ _ P _ _ Q _ _ R _ _

S _ _ T _ U _ _ V _

W _ _ X _ _ Y _ _ Z _ _

Now You Try It!

start

a a **a** a

b b **b** b

C C **C** C

Now You Try It!

start

𝒹 𝒹 𝓭 𝓭 _____

ℯ ℯ ℯ ℯ _____

𝒻 𝒻 𝒻 𝒻 _____

Now You Try It!

start

g g g g

h h h h

i i i i

Now You Try It!

j j j j _____

k k k k _____

l l l l _____

Now You Try It!

Now You Try It!

p p p p p _____

start

q q q q _____

meet

r r r r _____

Now You Try It!

Now You Try It!

Now You Try It!

y y y y y _____

z z z z z _____

lowercase 1 bones

a b c d e

f g h i

j k l m n

o p q r

s t u v w

x y z

you add the body!

go for it!

a___ b___ c___ d___

e___ f___ g___

h___ i___ j___ k___

l___ m___ n___

o___ p___ q___ r___

s___ t___ u___ v___

w___ x___ y___ z___

Now You Try It!

A A A A

Start

B B B B

C C C C

Now You Try It!

Now You Try It!

Now You Try It!

J *J* *J* *J* _____

K *K* *K* *K* _____

L *L* *L* *L* _____

Now You Try It!

\mathcal{M} \mathcal{M} \mathcal{M} \mathcal{M}

\mathcal{N} \mathcal{N} \mathcal{N} \mathcal{N}

\mathcal{O} \mathcal{O} \mathcal{O} \mathcal{O}

Now You Try It!

P P P P _____

Q Q Q Q _____

R R R R _____

Now You Try It!

Now You Try It!

\mathcal{V} \mathcal{V} \mathcal{V} \mathcal{V} _____

\mathcal{W} \mathcal{W} \mathcal{W} \mathcal{W} _____

\mathcal{X} \mathcal{X} \mathcal{X} \mathcal{X} _____

Now You Try It!

\mathcal{Y} \mathcal{Y} \mathcal{Y} \mathcal{Y} \mathcal{Y} _____

\mathcal{Z} \mathcal{Z} \mathcal{Z} \mathcal{Z} _____

uppercase 2 bones

A B C D E

F G H I

J K L M N

O P Q R S

T U V W

X Y Z

you add the body!

go for it!

A _____ B _____ C _____ D _____

E _____ F _____ G _____

H _____ I _____ J _____ K _____

L _____ M _____ N _____

O _____ P _____ Q _____ R _____

S _____ T _____ U _____ V _____

W _____ X _____ Y _____ Z _____

Now You Try It!

a a a a _____

b b b b _____

c c c c _____

Now You Try It!

start

d d d d

e e e e

f f f f

Now You Try It!

g g g g _____

h h h h _____

i i i i _____

Now You Try It!

Now You Try It!

m m m m _____

n n n n _____

o o o o _____

Now You Try It!

Now You Try It!

Now You Try It!

Now You Try It!

lowercase 2 bones

a b c d e

f g h i

j k l m n

o p q r s

t u v w

x y z

you add the body!

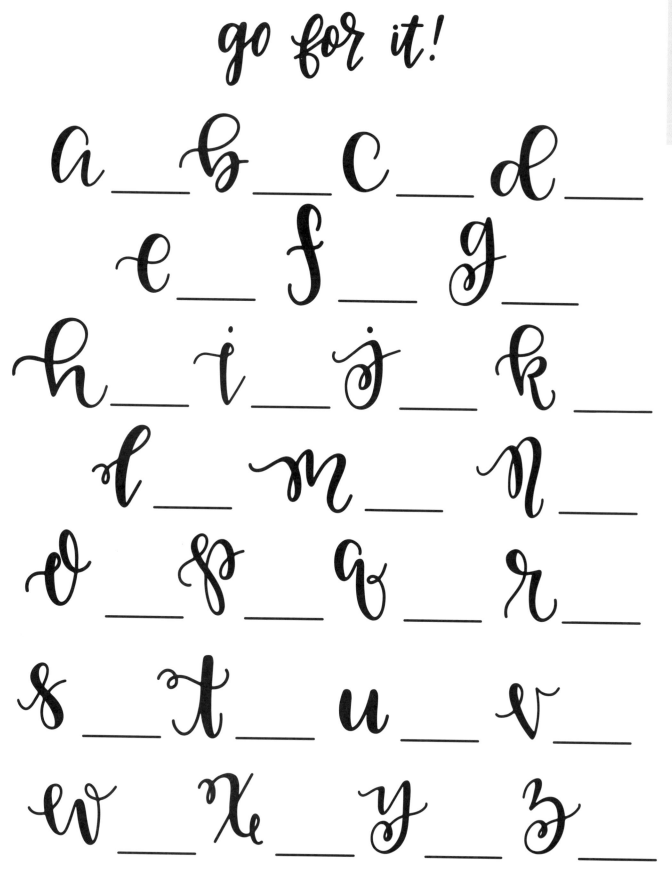

go for it!

a___ b___ c___ d___

e___ f___ g___

h___ i___ j___ k___

l___ m___ n___

o___ p___ q___ r___

s___ t___ u___ v___

w___ x___ y___ z___

The Alphabets 83

Now You Try It!

A A A A _____

B B B B _____

C C C C _____

Now You Try It!

\mathcal{D} \mathcal{D} \mathcal{D} \mathcal{D} _____

$\mathcal{E}e$ $\mathcal{E}e$ $\mathcal{E}e$ $\mathcal{E}e$ _____

\mathcal{F} \mathcal{F} \mathcal{F} \mathcal{F} _____

Now You Try It!

G G G G

H H H H

J J J J

Now You Try It!

\mathcal{J} \mathcal{J} \mathcal{J} \mathcal{J} _____

\mathcal{K} \mathcal{K} \mathcal{K} \mathcal{K} _____

\mathcal{L} \mathcal{L} \mathcal{L} \mathcal{L} _____

Now You Try It!

M M M M _____

N N N N _____

O O O O _____

Now You Try It!

P P P P

Q Q Q Q

R R R R

Now You Try It!

S S S S _____

T T T T _____

U U U U _____

Now You Try It!

V V V V V _____

W W W W W _____

X X X X X _____

Now You Try It!

Y Y Y Y _____

3 3 3 3 _____

uppercase 3 bones

A B C D E
F G H I J
I K L M N
O P Q R S
T U V W
X Y Z

you add the body!

go for it!

A___ B___ C___ D___

E___ F___ G___

H___ I___ J___ K___

L___ M___ N___

O___ P___ Q___ R___

S___ T___ U___ V___

W___ X___ Y___ Z___

Now You Try It!

Now You Try It!

d *d* *d* *d* _____

l *l* *l* *l* _____

b *b* *b* *b* _____

Now You Try It!

g g g g _____

h h h h _____

i i i i _____

Now You Try It!

j *j* *j* *j* _____

k *k* *k* *k* _____

l *l* *l* *l* _____

Now You Try It!

m m m m m _____

n n n n n _____

o o o o o _____

Now You Try It!

Now You Try It!

s s s s _____

t t t t _____

u u u u _____

Now You Try It!

Now You Try It!

y y y y _____

z z z z _____

lowercase 3 bones

a b c d e

f g h i

j k l m n

o p q r s

t u v w

x y z

you add the body!

go for it!

a____ b____ c____ d____

e____ f____ g____

h____ i____ j____ k____

l____ m____ n____

o____ p____ q____ r____

s____ t____ u____ v____

w____ x____ y____ z____

Now You Try It!

Now You Try It!

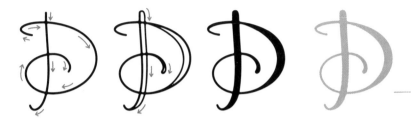

Now You Try It!

Now You Try It!

J J J J J _____

K K K K _____

L L L L _____

Now You Try It!

M M M M

N N N N

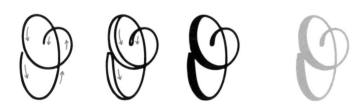

Now You Try It!

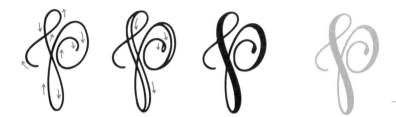

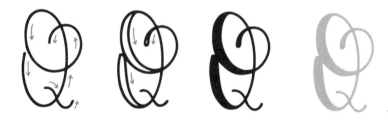

Now You Try It!

8 8 8 8 _____

T T T T _____

U U U U _____

Now You Try It!

Now You Try It!

uppercase 4 bones

A B C D E

F G H I

J K L M N

O P Q R S

T U V W

X Y Z

you add the body!

go for it!

A _____ B _____ C _____ D _____

E _____ F _____ D _____

H _____ I _____ J _____ K _____

L _____ M _____ N _____

O _____ P _____ Q _____ R _____

S _____ T _____ U _____ V _____

W _____ X _____ Y _____ 3 _____

Now You Try It!

a *a* **a** *a* _____

b *b* **b** *b* _____

c *c* **c** *c* _____

Now You Try It!

Now You Try It!

g g g g _____

h h h h _____

i i i i _____

Now You Try It!

j j j j _____

k k k k _____

l l l l _____

Now You Try It!

Now You Try It!

Now You Try It!

S S S S

t t t t

u u u u

Now You Try It!

v v v v v

w w w w

x x x x x

Now You Try It!

lowercase 4 bones

a b c d e

f g h i

j k l m n

o p q r s

t u v w

x y z

you add the body!

go for it!

a___ b___ c___ d___

e___ f___ g___

h___ i___ j___ k___

l___ m___ n___

o___ p___ q___ r___

s___ t___ u___ v___

w___ x___ y___ z___

The Alphabets 127

Now You Try It!

A A A A

B B B B

C C C C

Now You Try It!

𝒟 𝒟 𝒟 𝒟 𝒟 _____

ℰ ℰ ℰ ℰ _____

𝔉 𝔉 𝔉 𝔉 _____

Now You Try It!

G G G G _____

H H H H _____

J J J J _____

Now You Try It!

\mathcal{J} \mathcal{J} \mathcal{J} \mathcal{J} \mathcal{J} _____

\mathcal{K} \mathcal{K} \mathcal{K} \mathcal{K} _____

\mathcal{L} \mathcal{L} \mathcal{L} \mathcal{L} _____

Now You Try It!

M M M M _____

N N N N _____

O O O O _____

Now You Try It!

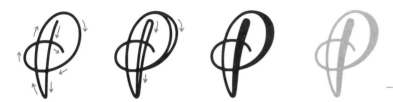

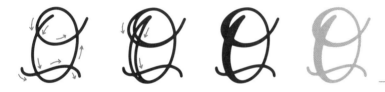

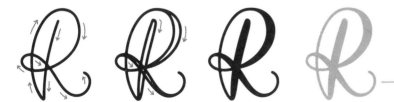

Now You Try It!

S S S S _____

T T T T _____

U U U U _____

Now You Try It!

Now You Try It!

Y Y Y Y

Z Z Z Z

uppercase 5 bones

A B C D E

F G H I J

K L M N N

O P Q R S

T U V W

X Y Z

you add the body!

go for it!

A _____ B _____ C _____ D _____

E _____ F _____ G _____

H _____ I _____ J _____ K _____

L _____ M _____ N _____

O _____ P _____ Q _____ R _____

S _____ T _____ U _____ V _____

W _____ X _____ Y _____ Z _____

Now You Try It!

a a a a _____

b b b b _____

c c c c _____

Now You Try It!

𝒹 𝒹 𝒹 𝒹 _____

ℯ ℯ ℯ ℯ _____

𝒻 𝒻 𝒻 𝒻 _____

Now You Try It!

g *g* *g* *g*

h *h* *h* *h*

i *i* *i* *i*

Now You Try It!

j *j* *j* *j* _____

k *k* *k* *k* _____

l *l* *l* *l* _____

Now You Try It!

Now You Try It!

Now You Try It!

Now You Try It!

Now You Try It!

y y y y

z z z z

lowercase 5 bones

a B c d e

f g h i

j k l m n

o p q r s

t u v w

x y z

you add the body!

go for it!

a __ __ b __ __ c __ __ d __

e __ __ f __ g __

h __ i __ j __ k __

l __ m __ n __

o __ p __ q __ r __

s __ t __ u __ v __

w __ x __ y __ z __

Word Practice

Add Some Bounce

Modern calligraphy is all about the bounce! This just means that the letters fall below and above the guideline with a fun and, sometimes, unpredictable flow.

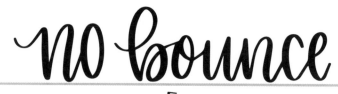

all letters stay at the guideline

Have fun taking letters that have a stem or tail and dropping them below the guidelines in an exaggerated way. Bounce comes when you mix it up by having the next letter stay at the guideline. Look at the following examples, but this is really where you can create your own lettering style.

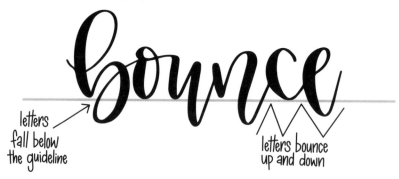

letters fall below the guideline

letters bounce up and down

Practice making your letters dance around the line!

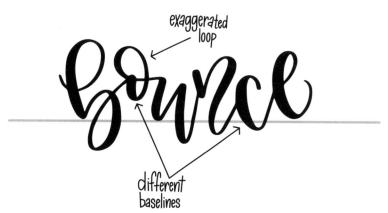

exaggerated loop

different baselines

Lift Your Pen

When connecting your letters, don't be afraid to pick up your pen. Personally, I draw until it feels natural to stop. Then I pick up my pen and start on the next letter until it feels natural to stop again. Here is a breakdown of how I stop and start for the word *grace*.

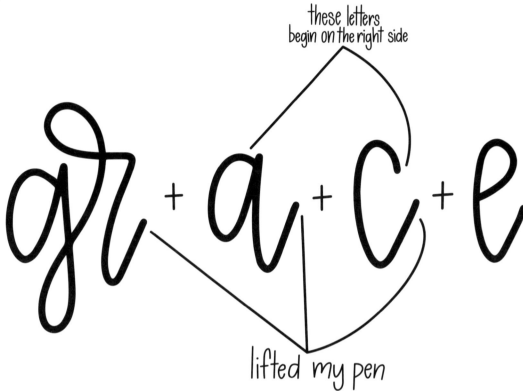

these letters begin on the right side

lifted my pen

After you thicken your downstrokes, the connections are hidden and create the illusion that you never picked up your pen.

connections are hidden

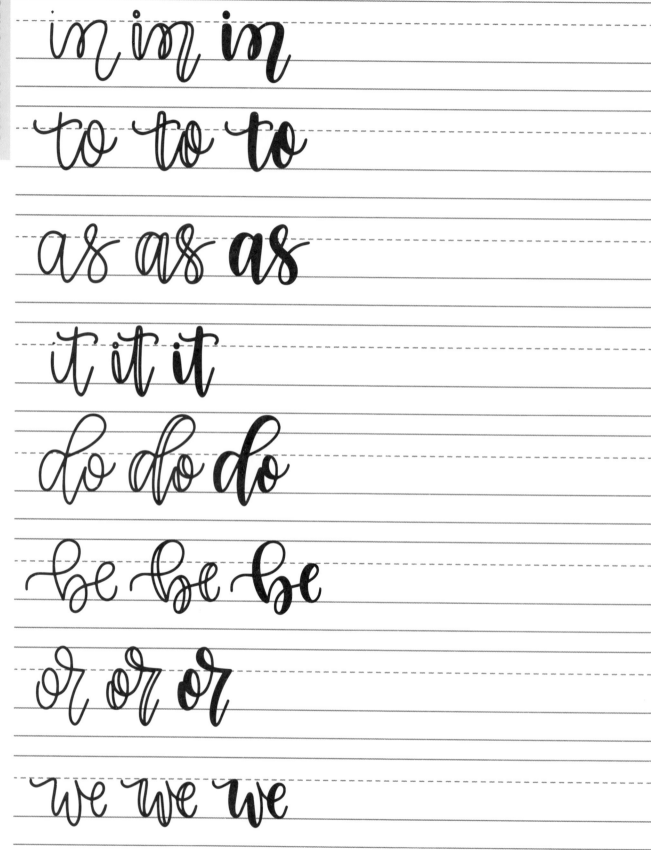

in in in

to to to

as as as

it it it

do do do

be be be

or or or

we we we

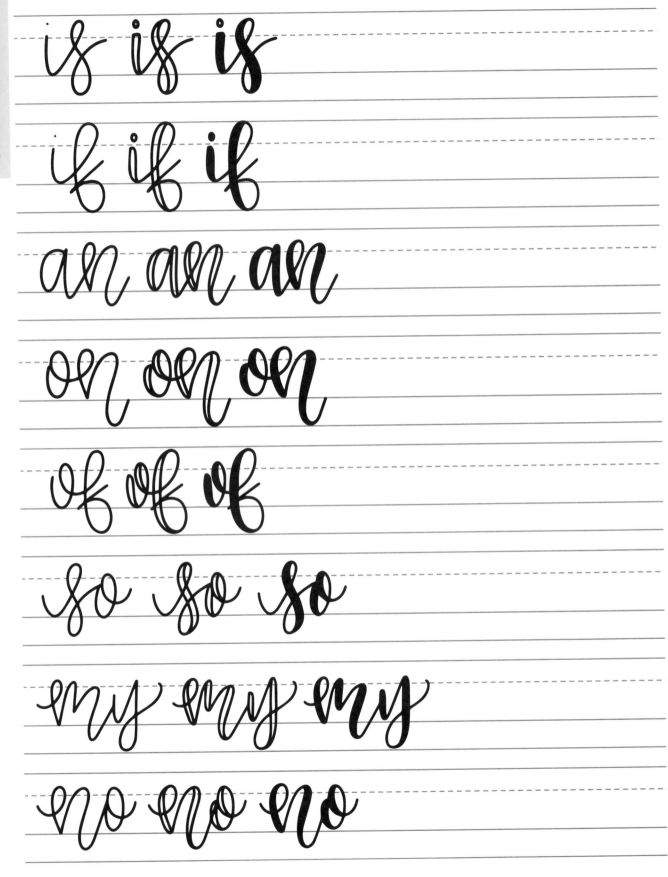

is is is

if if if

an an an

on on on

of of of

so so so

my my my

no no no

the the the the

with with with

and and and

this this this

but but but

what what what

you you you

they they they

About the Author

The Lord knows all our imperfections yet He loves us beyond all comprehension! Psalm 103:14 says, "For He knows our frame, He remembers that we are dust."

A couple years ago my Savior, Jesus Christ, showed me just how shallow life is without Him. By His grace, He called me out of my mess. Jesus has brought joy, contentment, love, peace, freedom, and so much more into my life. He delivered me, and I owe Him everything.

Prior to ever starting my artwork, I had been praying for God to use my life for His glory. I pray each piece of art created by Imperfect Dust glorifies my Father and blesses someone's life or home!

I started lettering signs as a local venture and it has grown beyond my imagination. Since then, Imperfect Dust has had art featured in large retail stores like Marshalls, At Home, Hobby Lobby, and Kirklands.

Teaching lettering seemed like a natural next step, and I found a new love for connecting with the students and watching their eyes light up as they learned. I was so excited to venture into creating a workbook so others can create lettering in a simple, fun way!

If you want to learn more about lettering or see video tutorials to accompany this book, check out my website www.ImperfectDust.com. I also share all my favorite lettering tools in my Amazon storefront at www.Amazon.com/Shop/ImperfectDust.

Acknowledgments

First, I praise God for my hands and giving me the ability to letter!

To my husband, Joey Stringer, thank you for always encouraging me and helping me juggle our crazy life together. You support me no matter how big I dream, and then push me to dream bigger. God blessed me with much more than I deserve when He gave me you.

To my boys, Dallas, Eli, and Luke, I hope the publishing of this book inspires you to dream without limits and live your life boldly for Jesus. I am so proud of you three and can't wait to see how God uses you for His glory.

To my mom, Johnette Burns, thank you for being the first to invest in my lettering journey by giving me a huge box of old picture frames that became my first chalkboard projects. You saw potential in me that I couldn't see.

To my daddy, Danny Burns, there is absolutely no way Imperfect Dust would be what it is today without you. Thank you for always being willing to help, making amazing quality signs, and even babysitting the kids when necessary. You have taught me what it means to have integrity, be selfless, and never give up.

To my sister, Alexis Burns, for her willingness to be the best "Aunt Lexie" we could ask for, and always being there for my crazy, last-minute request.

Ronnie and Dorothy Burns, thank you for your prayers and for providing me with spiritual growth my entire life.

Index

Note: Page numbers in *italics* indicate projects.

trace
&
frame

NEVER-theless
She Persisted

Creativity takes courage

joy comes in the morning

— PSALM 30:5 —

done
is
better
THAN
perfect

Art

READY TO FRAME

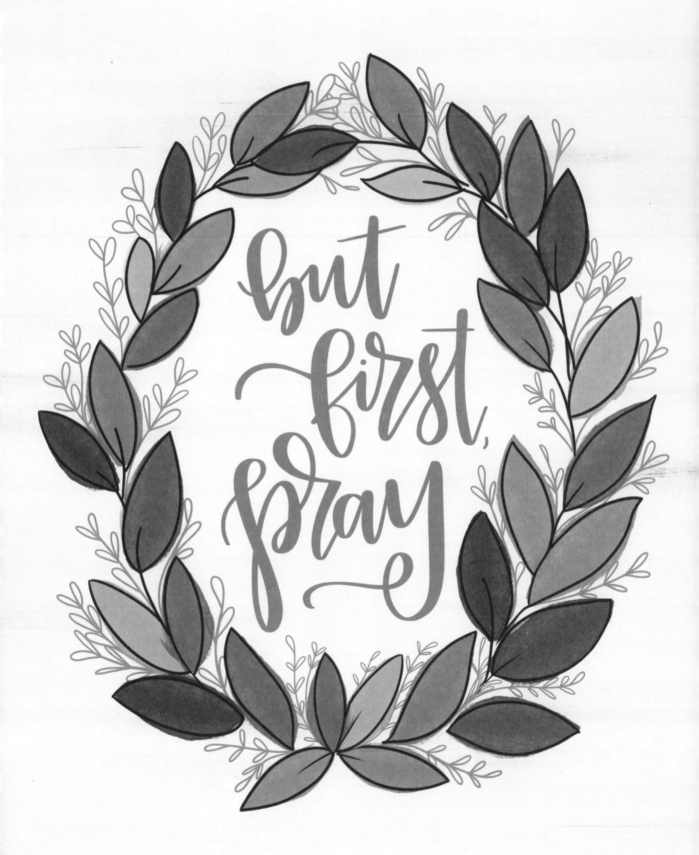

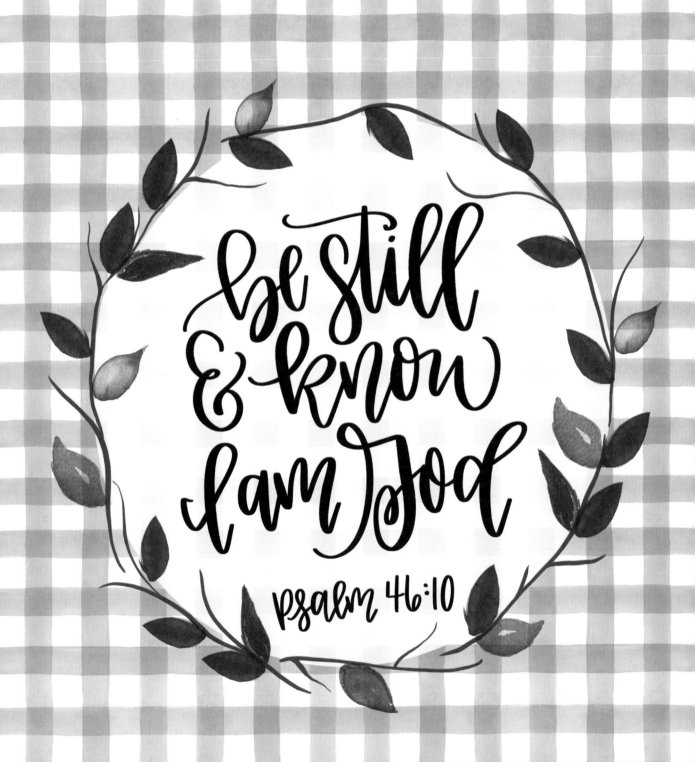

be still
& know
I am God

psalm 46:10

fear is a liar